MT

709.2/SYM

DUBLIN

# earthworks

# earthworks

## DERVAL SYMES

## P. KEARNEY BYRNE

Published in 2005
by backYard books, Co. Leitrim, Ireland.

A CIP record for this
title is available from
The British Library

isbn 10 0-9551092-0-5
isbn 13 978-0-9551092-0-1

cover : Ghost Ship, 2004 oil, 54x46 (Fiona Ward).

*earthworks* can be purchased through our website
www.backyardbooks.info

photography : *Julie Kearney*.

ACKNOWLEDGEMENTS
A special thanks…
    To Phil Byrne, for your determination, tenacity and incredible hard work which has carried this project through to its conclusion. Your belief in the work and your sensitive and thought-provoking interpretation of its meaning has opened it up to a new audience.
    To Julie for all of your support, wisdom, creative input, and timely sense of humour, and especially for rescuing all those paintings from the inferno.
    Also to Maura Hickey for being so generous in giving up your time to scan these images and for all your advice during this project, and also thanks to all the friends and family who have supported me over the years.                                                                D.S. 2005

    Thanks to: our sponsors, also to anna-marie o'rourke, caomhin corrigan, mari-aymone djeribi, joanne robertson and siobhan walshe. Special thanks to marie o'kelly for her editing and fundraising.                                                                P.K.B

# INTRODUCTION

In urban environments we can feel lonely, but in reality, we are never truly alone. There will be another human being, a stranger perhaps, within 500 yards of us. That's almost the definition of a city. The fact that other people, lots of them, exist in such close proximity makes it difficult to tear one's attention away, for any length of time, from the interpersonal, that is, from the socio-cultural-economic-political. Naturally, this has a huge impact on what matters in city life. The dominant relationship in urban areas, no matter how well we cloister ourselves away in our apartments or semi-d's, is between one human psyche and another. This is reflected in all areas, including the art world. The social, cultural, economic and political dominates.

But, move way out of the cities and there is a bracing and dramatic shift of awareness from the smaller wheel of the political-cultural to the overarching intensity of the existential and the spiritual. In a landscape dominated by rock, wind and stars, the primary relationship is not of one human being to another, but of Self to Universe.

Derval Symes has positioned herself at this interface.

Derval Symes says that if her work were to be classified it would be as landscape painting. One could hardly disagree with that. However, she is a landscape painter in a particular way. Not, for example, in the hairy, cave-dwelling sense of Barrie Cooke, nor in the sense of Nick Miller, obsessively recording every leaf and twig from the confines of his trusty van. In fact, unlike either Cooke or Miller, or indeed most other landscape painters, Symes rarely names any actual location.

Derval Symes loves being out in nature. However, she doesn't sketch outdoors or take photographs. She never consciously brings any image from her wanderings home to her studio. This is in keeping with a way of working which has developed over the years, or more truthfully, it is a way of working that has found its home in her. This modus operandi commits her to staying painfully open to what emerges from interaction with pigment and canvas, and excludes conscious introduction of any image into the process. Georges Braque said 'The painter should put (her)self in rhythmic or formal sympathy with nature but not imitate it'.[1] Symes, I believe, is doing exactly this, but at a level of physiology, rather than intellect or feeling. As a painter, her relationship to landscape exists far below the level of consciousness.

Her work-space, for instance, has one small window which faces a high hedge. When I suggested that she might consider putting a bigger window on the other side of the studio, facing instead the expanse of fields which rise toward the Slieve an Iarainn mountains, she recoiled in horror at the thought of being so distracted. Two years later, for the '*Echoes*' exhibition in 2004, she produced a work, an image that surprised her with its unusual lack of ambiguity. The painting in question is '*Mountain*' (plate 26). Symes would never consciously choose to paint a mountain. But there can be no doubt it is the same Slieve an Iarainn which was, she thought, banished as a distraction, but nevertheless made its claim on her.

And so, whereas Barrie Cooke, with his at-one-with-nature assuredness, perhaps embodies the archetype of the Primitive, and Nick Miller resonates with the archetypal energy of the Scientist or Alchemist, Derval Symes seems most closely aligned with the archetype of the 'Seer' or Poet.

I remember seeing William Crozier's painting 'Banon Provence'.[2] I saw it once, though I looked at it for a long time. What I remember is the 'shocking pink' colour that dominated this small canvas. I was transfixed. The pink colour together with a dark green nearer the edge of the canvas literally made my eyes 'hot'… The sensation was strangely enjoyable and compelling… I would have stood there, staring, just for that experience alone.

Every sensation has feelings and thoughts and intuitions associated with it. What these feelings and thoughts and intuitions are is unique to each individual, like a fingerprint or DNA. In painting, it is the sensations generated by colour, texture, use of space, and so on, that lead the encounter. This is how

sensate painters engage us. In the case of the Crozier painting mentioned above, the feeling generated in me by the 'hot eye-ball' sensation was excitement with something akin to joy skidding across it.

Carl Jung maintained that in coming to know ourselves, in making sense of ourselves and our world, we can utilise four psychological functions. These functions are: Thinking, Feeling, Sensation, and Intuition. They are all linked, though we usually choose to lead with one. Knowing our 'lead function' helps us to avoid making obvious mistakes in our life choices.

This simple model can be applied to the work of any given artist. If you've plumped for conceptual art just as well to check with your friends how they rate your engagement with your own thinking. There's nothing more frustrating than conceptual art where the thinking is sloppy, trite or absent – and nothing more enjoyable than when such work is rich with intellectual fibre and challenge. Again, if feelings aren't your thing, hopefully you will steer away from performance art where an instinctive grasp of dramatic rhythm, emotional depth and inter-relatedness is demanded.

Thus for me, it is a contradiction in terms to speak about a painter who isn't sensate. If colour, texture, shape, surface, thickness, thinness, slipperiness etc., don't mean something to you as an artist, why use them to express yourself, particularly when there is such a wealth of other possible media available? Why use pigment if its sensual qualities don't matter to you?

Derval Symes is a painter who is in love with paint, especially oil paint, and this shows in her work. She leads with her capacity for the sensate, and as I've said, I believe this is a necessary starting point for any serious painter. But equally importantly, Symes engages with pigment and solvents as though they have a life of their own. It is impossible to consciously manufacture or contrive the physical textures or the subtleties of colour that are found in her work.

Symes considers herself to be one part of a complex relationship. Her assertion is not as naïve as it might have once sounded. The new sciences are challenging our notion of consciousness. We accept that we are made of the stars so to speak. We believe that absolutely everything that is in us, in terms of atoms and molecules and the rules that govern them, originates outside us. But, for some reason, naïvety perhaps or arrogance, we exclude consciousness from this reckoning. Consciousness, we like to think, originates in human beings and exists nowhere else but in us. Animals, mountains, oceans, awesome or beautiful as they might be, don't possess intention or consciousness. The new sciences are challenging this anthropocentric thinking. We are being asked to take seriously the ancient beliefs that the 'gods', consciousness by another name, exist just as much in the rocks and subsoil as they do in the heavens or in humanity.[3] 'Mind' may indeed be in us precisely because it is already a feature of the universe. And so when Symes says that she waits for the image to emerge from the paint, she means this literally.

This is a courageous stand to take in a largely secular Western art world. We can no longer dismiss it

as either a metaphor for unconscious processes or as some form of primitive or romantic animism. This is profoundly different from regarding paint as inanimate – a material into which with enough skill and talent we can omnipotently inject, as it were, some of our own life energy. To put it another way: it's not just that Symes has something to say through paint but that she is open to pigment itself having things to say. After all, what are these pigments made from but rocks, soil, charred bones, and chemical compounds all taken, ultimately, from the biggest living organism with which we have contact: Earth.

In the studio Symes can appear very active, working sometimes with frenzied movement to and from the canvas. However, her activity disguises her commitment to the largely invisible process of receptivity. There are obviously risks associated with this way of working. Because she must find her way into the work, composition can't be planned in advance. To some extent she has had to jettison conscious attention to the exploration of space across the surface.

However, Symes' engagement is with 'spaces' rather than 'space'. She is less concerned with expanse than with depth, depths which are reached, concealed, exposed, buried again. The primary movement is, in fact, up and down through the surface. The tension is between the layers of pigment, between areas that adhere and conceal and areas that are suddenly revealed. These layers are not heavy or dense in the way that, for example, Gwen O'Dowd's surfaces are. Rather they achieve lightness through being laid down then taken away – worn away – as though by time, time which has been telescoped in the studio.

The colours are often muted, opalescent, not quite defining themselves, and most often occur, seductively, as interstices rather than in blocks. Her surfaces often mimic, or maybe reconstitute, deposits and erosion, washing away and sedimentation. 'Moss Stone' (plate 16), unstructured compositionally, but somehow exquisitely alive, could be the surface of a rock, perhaps embedded with turquoise deposits, that has been exposed on a hillside. Wasn't it the critic Patrick Heron who articulated this so well when he spoke about the 'aliveness' inherent in granite or in an old green barn door?

It's interesting to contrast Symes' work with that of Sonia Shiel, a painter also associated at one point with the Apploft Gallery in Easkey. Shiel has a gift with space across the surface and this is part of the 'wow' factor in her canvases. The effect of comparing the work of these two painters is something like experiencing the differences in the landscapes of Galway and Leitrim. Galway has those big sweeping vistas that are impossible to ignore, that are immediately breath-taking in the way that Shiel's work often is. The sensation of big spaces outside us, whether in a landscape or a painting, sets up a corresponding

resonance inside us.

But Leitrim is very different. It is a shy county that reveals its deeper beauty and its secrets slowly, and perhaps it is not accidental that this is where Symes has chosen to live. Because her work is not acquisitive – she doesn't move across the surface of the canvas in a muscular and exploratory manner – her paintings, even when the scale is large, are deceptively intimate. These works challenge us to take time, to become receptive and quiet, allowing ourselves to be drawn inwards and, often, downwards. They almost need to be 'sniffed' up close and it is the seductive use of textures and pigments that draws us near enough to do just this. These paintings are slow and subtle and they need to be lived with, noticed over and over again, until we find that, rather like the hedgerows and small raggedy fields of Leitrim, their beauty has crept up on us.

Symes has said that when she was younger she painted the 'places where people had once been' and indeed there are rarely people present in her work. Her preoccupation with empty spaces has continued. When creatures more consistently appear in her recent work (see *Echoes*) they do so, not in full-bodied manner, but rather as traces, or imprints, of what has once been. Here again her work resonates with Leitrim, a county effectively 'emptied out' after the famine to become saturated by absence.

As the psychoanalyst Wilfred Bion reminds us,[4] art can make something beautiful out of something ugly or frightening. When we are able to find a place for them in our lives, heartbreak, illness and loss are deepening, soulful experiences rather than catastrophes. The process of discovering meaning is what makes possible this transformation from the unbearable to the precious. All serious art confronts us with aspects of the challenge of existence. It also creates a metaphorical or imaginal space where meaning-making can happen in that encounter.

In engaging with Derval Symes' paintings it is impossible to avoid an encounter with our powerlessness, our aloneness and with loss. The adamant and exacting organic processes and the monumental erosions and sedimentation that govern movement on this planet breathe and lie in wait beneath, and within, the skeins and layers of pigment on her canvas. Because there is no 'other' we are solitary in facing the passage of time, the archaeology of absence so resolutely configured in the work. The implicit challenge in these paintings lies in their silent invitation to find a place for such experience.

P.K.B. 2005

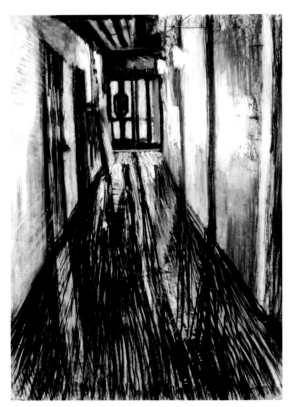

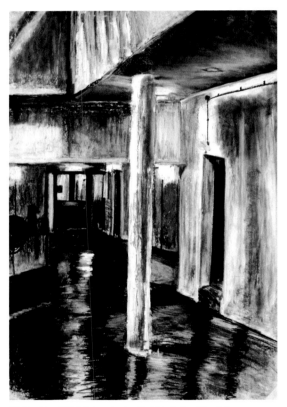

**1a** Corridor, 1988–9 charcoal and conté, A3 (collection of the artist).

**1b** Corridor, 1988–9 charcoal and conté, A3 (collection of the artist).

# BLACK WHITE COLOUR
## (1987–1991)

*They used to get annoyed with me at college, they didn't understand the way I worked, they didn't see the point of the way I worked.*
<div align="right">D. Symes 2005</div>

There are two strands in Symes' early work I'd like to call attention to. The first concerns her engagement with colour. She describes arriving in college in England dressed in multicoloured clothes with bright orange hair – at a time when black was the new black and everyone else was in cool monochrome. What she put into her dress sense however, she simply couldn't put into her painting and much of her work at this time was in black and white.

Using colour was frightening for her. She says it was 'like driving a car too fast' and her emotions were 'too big' for colour to be anything other than way over the top. When she did experiment in those early years, it was usually in the style of one of her first heroes, Jack B. Yeats. Her early paintings were notable primarily for their rampant explosions of colour and romantic titles such as '*Travellers*' (plate 2).

During this difficult time Symes soothed her soul by focusing on drawing, usually in charcoal. When other students had returned to classes after breaks, she stayed sketching in the corridors, drawn by the

709.2/sym

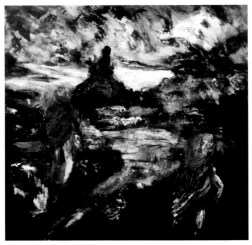

**2** Travellers, 1988 oil (destroyed).

resonance of the places 'where people had been'. What remains of these drawings shows them to be austere and structured – bony, spare drawings of deserted spaces, full of lines, edges and angles ('*Corridors*' plate 1a and 1b). With hindsight of course, her early attraction to the 'empty' space seems very much in keeping with her more mature work, heavy with absence.

The second theme concerns her struggle with form and formlessness. By the time of her degree show in 1991 Symes had begun to find her way into relationship with pigment. These works, some of which were later exhibited in a group show at the Powerhouse in Dublin in 1993, show much better colour handling. The paintwork is energetic and alive, and there is a sense of the development of a palette that has meaning for her (see '*EarthFire*' plate 15). In many ways these works hold their own even at this early stage, but strong compositional elements and structure are not yet in place. As a result, to my mind, the paintings, while fluid and expressive, remain ephemeral and lack substance and weight. It is as though Symes hasn't been able to muster the sturdy skeletal system of her monochrome work, the precise feature that may have given the swirling intricate paint the necessary containment and body. It seems that, at this point, colour and structure have formed a polarity. It is a polarity that Symes grapples with over the coming years, and is one of the most important internal dynamics in the development of her mature art.

Symes' titles, both for individual paintings and for exhibitions, are always significant. These early works are named after the elemental forces of Earth, Fire, Water and Air. While her work is always concerned with the universal rather than the particular, Symes' later titles contain references to more specific structures or life forms. In creation mythology it is always the elements that are first separated from the void. An initial period of chaotic formlessness exists before a condensation into form manifests itself. It is as though, over the years, Symes' own creative expression closely follows this universal prototype, and soon, out of the eddying patterns, more solid shapes and structures begin to condense.

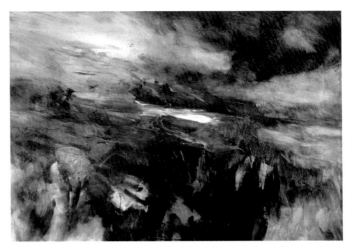

**3** Wicklow, 1994 oil, 75x91 (Oran and Catherine Symes).

# SECRET SHAPES
## (1992–2000)

Some people have a talent that is whole and entire, an acorn that will, if nurtured, become an oak. Others, like Symes, have a talent that is fractured, a gift which needs to be re-membered over time and put back together again. Her work then becomes synthesis-seeking. The years between 1992 and 2000 were especially important in terms of her endeavour to synthesise form and colour.

In the first few years after leaving college Symes began to introduce some structured elements into her works with oils. '*Untitled*' of 1993-4, for instance (plate 4) is her courageous effort to integrate rough geometrical shapes, mainly rectangles, into a small painting.

A far more successful and, I believe quite important painting, is '*Energy*' of the same year (plate 5). The rectangles, which appeared somewhat clumsy in the previous work, are here in effective relationship to each other. It is this relationship to each other that, from this point on, they tend to 'seek out' in her work. Patrick Heron[5] used to say that all painters had their secret abstract forms – squares, diamonds, etc. concealed beneath the surface of their work. One of Symes' secret shapes is revealed in this painting and is what I call a T-Square.

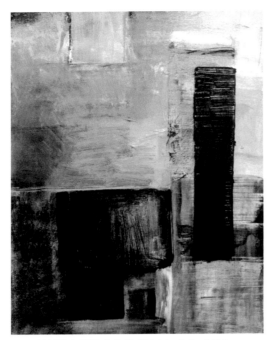

**4** Untitled, 1993–4 oil, 45x53 (private collection, Dublin).

The T-Square structure in '*Energy*' consists of horizontal bands across the top half of the painting (the first rectangle) together with a vertical band that drops from this down to the lower edge of the canvas (the second rectangle). There is then, an upper half with what might be called an 'horizon' line and a shaft that descends through the 'earth' into its depths. Symes has said that she has always had a particular awareness of earth and sky and this structure emphatically links both. The emergence of this compositional element is certainly part of what was waiting to happen in her struggle to bring together form and colour.

The T-Square is a strong and imposing structure visually. If not handled carefully it can easily dominate a work and crush its spontaneity, rendering it heavy and lifeless. It has interesting mythological associations and these perhaps shed some light on why this particular shape has such a powerful effect on the psyche. The T-Square is, for instance, an ancient form of the crucifix. At a subliminal level, therefore, it has as much effect on the Western psyche as the image of the more modern Christian cross. On this symbolic level it is considered a metaphor for the anguish of the soul crucified in matter and signifies the existential struggle: Do we experience the limitations of the physical world as containing or as imprisoning? A Jewish saying sums up this tension: 'Body without Spirit is corpse, Spirit without Body is ghost'.

These ideas hint at the underlying scaffolding in Symes' work. One might speculate that beneath the harmonious colours and the apparent chaos and fluidity of her brushwork lies this obdurate construction which, unless treated with due respect, will imprison rather than contain the spirit of the painting. I have heard Symes say how afraid she is of the possibilities in the painting being over before they have begun – that she has a fear of things becoming static, stagnant or trapped. It seems to me that these are statements that apply, both visually and psychologically, to the dangers of working with such powerful geometric elements as the T-Square. In a sense it is as though the real battle has become defined. What appeared to be a clash of colour and form has shown itself as the age-old conflict between body and soul, youth and age, the ephemeral and the enduring, Eros (Love) and Thanatos (Death).

Having come to this level of resolution Symes' work in the next few years relaxes into familiar territory ('*Wicklow*', plate 3). Then suddenly, out of this easy place comes an unusual and striking painting, '*Viking*' (plate 16).

'*Viking*' has all the energy and chaos of the elements work in her degree show, but this time there is focus and purpose. The two emerging figures (Viking and Stag) justify the whirlwind of colour, defining the space and giving it vigour. This painting is an exception in many ways, not least because there is a human figure in it – albeit a part figure with his back turned towards us – but also because it is transitional. The painting marks an end, because it was the last time Symes used an image sketched prior to working on the canvas, and a new beginning. From then on, she commits herself to working solely with images and shapes that emerge in the process of her painting.

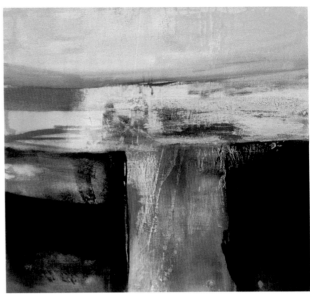

**5** Energy, 1993–4 wax acrylic, 45x53 (collection of the artist).

At the time this painting was made Symes was living in Stoneybatter, in the heart of Viking territory. However, the figure of the Viking appeared, without her conscious awareness, from the process alone. He was 'found' in the work. At the time Symes was still sketching from nature, and the deer in Phoenix Park were a favourite subject. She introduced the Stag into the work as a compositional device, an essential and effective one, which brings balance to the upper half of the painting. He is, however, the last instance of deliberate imposition to be found in her work.

Next came a quieter time of consolidation. Symes' work seems more embodied and substantial, more sure. Other, perhaps less central, shapes begin to show themselves ('eyes' or 'lenses' and sacs for instance – see '*Limb*' plate 6) and her work is more cohesive.

Suddenly, like the unexpected lifting of fog, another breakthrough occurs. The *Whale* painting is there (plate 17) with its magical silvery blue-green hues and tremendous elegance of composition. The squares and rectangles of the T-Square are present, but this time draped in a delicate patchwork of beautifully complex colours, with rich surfaces that shimmer with life and movement. In the lower left is a silvery white square, in part knifed on, in part with a brush that has spattered paint over the greenish

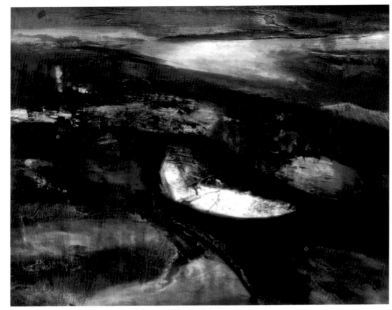

**6** Limb, 1995–6 oil, 61x76 (private collection, Dublin).

square beside it – again rich with organic markings and textures. Above this is a lavender rectangle, separated from the green square by a scraped and ridged yellowish horizontal. And to the left, the area that brings this whole composition to life, is a great jutting black form that is the Whale of the title, with its rough outline, disrupting the squares with its upward thrust, giving the whole composition a dynamism and monumentality that painters long to see in their work. This is the T-Square demonstrating its ferocious potential to underpin a work. We can be sure, as William Crozier[6] would say, that this painting won't 'fall down'.

Another painting from this period also demonstrates the power of this structure to organise and hold a work. The palette of *Vertebrae* (plate 8 – unfortunately the only available slide of this work doesn't do it justice) consists of a sombre but burnished combination of brown-blacks and silvery-greys. If we are reading it as landscape, the impression might be of a geological formation that has resisted the pressures of time and the weight of the soil and subsoil. Or perhaps we read it as a seascape with a boat in the right foreground and the silvery sea of an inlet behind? There again it could be a blow-up of a microscopic geological slide of sedimentary and igneous rocks – sandstone and granite perhaps, with slivers of mica visible? However we read it, we can be sure of its 'rock-solidness'. This is thanks once again to the T-Square, visible in the vertical rectangle that runs to the lower left edge of the canvas and in the horizontal bands of varying widths above this. The tension is well held and the composition dynamic. The submerged white rectangle to the right assists in holding the work in a tight format.

In both this work, and *Whale*, I believe a point of synthesis was reached and it was only after this that Symes could at last begin to claim her own territory.

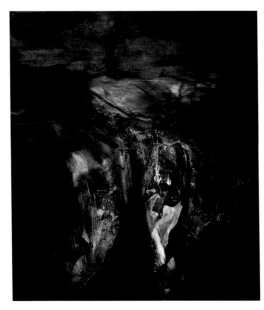

**7** Hard Core, 2001 oil, 76x91.5 (Eithne V. Wallis CB, England).

# EXCAVATIONS
## (2001) Appleloft Gallery

Excavations: to dig up, to lay bare, to uproot… Decayed matter builds up over time to create layers of soil and rock formations. We are also made up of layers of our own experiences. In order to know ourselves it is sometimes necessary to excavate our own past and those of our predecessors before we can move on to build our own foundations.　　　　D. Symes 2001

The move toward a 'defining moment' in a painter's development is a bit like trying to define when the puppy has become the dog. It is gradual and almost imperceptible, yet once it has happened it's impossible to deny that significant change has already occurred. The exhibition in Denise Clarke's Appleloft Gallery was, I believe, that defining moment in Derval Symes' work.

A lot had happened in her personal life, and it's almost impossible to talk about this exhibition without referring to this background. Both her parents had died in the previous 5–7 years, the house she had been brought up in had been sold – and levelled – and Symes and her partner had made the decision, in principle, to move out of Dublin.

The title of the exhibition was '*Excavations*'. The gallery, which was itself rather beautiful, was upstairs in a large open loft area. Though the canvasses were hung in a straightforward fashion, walking into this

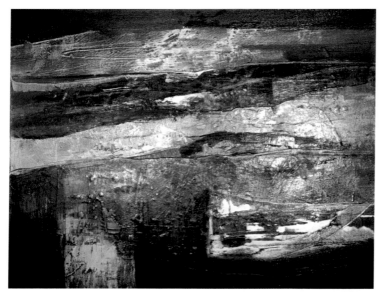

**8** Verterbrae, 1998–9 oil, 59x52 (private collection, Wicklow).

show was less like walking into a gallery and more like entering a cave. The colours were striking, impressive, and irresistible – a mixture of rich ochres and umbers with glistening areas of opalescent greens, blues and whites.

One can't really talk about '*Excavations*' without making associations to entombment and delivery. The show signified both death and birth, the mixture of earthy and iridescent colours reminiscent of tomb and womb, of things buried and unearthed, dead and putrefying, or slippery with birthing and life.

In terms of structure and content, many of Symes' secret shapes had now found their place. The horizontals and verticals perfectly suited the subliminal images of landscapes, mining and burial, the lenses and sacs redolent with being either entombed or in-womb.

The T-square composition is most obviously present in '*Grass Roots*' (plate 18) and also in '*Fools' Gold*' (plate 19) one of Symes' favourite paintings. The sacs and eye-shapes also make an appearance in a number of the works, '*Hard Core*' (plate 7) being a particularly good example.

In '*Excavations*' a mature cohesiveness of colour treatment was present throughout. However, the most significant new development was Symes' handling in the layering of paint. There had always been attempts, some successful, at luminosity (*Viking* plate 16 and *Whale* plate 17 are obvious example) but nothing reaching this level of spontaneous complexity. In these works, over and over, are skeins of brown and black and red-brown drawn across areas of white or ochre. They look sometimes like membranes from the insides of living creatures, sometimes like layers eroded by weathering or veils of muslin draped over areas lit from within. These skeins and veils (see for example *Amber* plate 9), dramatically alter the picture surface. The eye now moves back and forward, in and out of these paintings in a new way, registering different depths and subtle changes of placement of attention down through the picture surface.

This is not a perspectival shift in the usual way, but I believe it marks the point at which Symes begins to use the picture plane for depth in a way that is uniquely her own. She has moved into exploring a

different kind of space created on the surface. As I have said before, she is not acquisitive, she doesn't move across the canvas in conquering mode but rather moves down through it. It is here that this facility can be first observed. These mysterious layerings signify a tremendous deepening in the relationship with paint, a new mutual trust so to speak between paint and painter, and Symes' work since this time has had a different level of confidence and maturity.

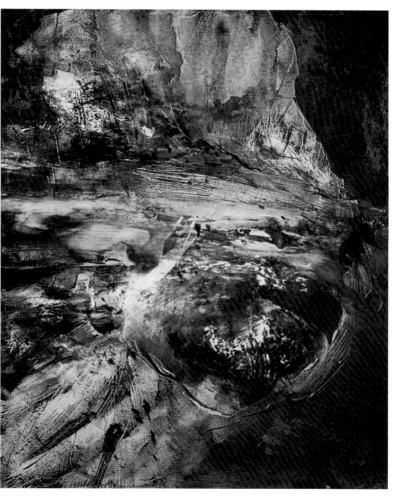

**9** Amber, 2001 oil, 60x75 (Mary Hyland).

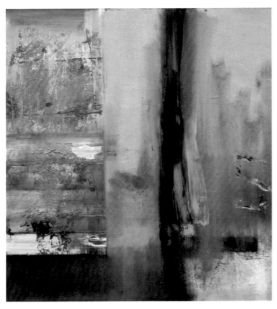

**10** Leitrim Dawn, 2002 oil, 91.5x102 (Patricia Scanlon and Ritchie Flynn).

# LEITRIM DAWN
## (2002) Powerscourt Townhouse

It seems to me that a painting is an organic living thing that is never finished, but frozen at a particular time by a dialogue between the artist and the canvas. A painting will go through several stages changing each time as layers are added or taken away. No ending or beginning, just a shifting fleeting thing, like a camera lens capturing a moment in time until another mark is made and the whole process starts again.          D. Symes 2003

By the time of the Powerscourt exhibition Symes had bought a cottage in Leitrim and was travelling down at weekends to get the property ready for the move. Perhaps the imminent change in lifestyle was reflected in the unusual nature of this show. It was, for instance, the first time that Symes had included a specific geographical location in the exhibition's title. The paintings were dramatically different, a real break in what had appeared to be a fairly consistent development in terms of composition and colour, mirroring perhaps the break in continuity occurring in her personal life.

    These were simpler, gentler paintings, the majority of them featuring a simple horizontal band of colour against a muted background of various shades of grey. The ochres, umbers and siennas of '*Excavations*' were absent, and in their place a slick of vivid cadmium red light, or cadmium yellow deep, set against a soft full grey (see *Untitled* plate 11 and *Twilight* 1 plate 12). There is now no longer an emerg-

ing – either threatening or promising – form beneath the horizon line. The compositions work in the simplest fashion.

These were probably the least complex paintings Symes had done to date, and the most expansive in terms of their 'breathability'. Gone, for now, are the skeins and veils, and in their place a lusciousness and creaminess of paint. There is, for her, an unusual amount of space suggested in spite of the thickness of the pigments.

In some way these works were, like her degree show, elemental, in that they mostly suggest air or water or light. But here the elements are at rest, not stormy or chaotic, and the simplicity of the compositions allows for a more leisurely pace in the looking. Because the eye is invited to settle at a single continuous layer at the surface of the canvas, the atmosphere is more gently contemplative than is usual with Symes' work.

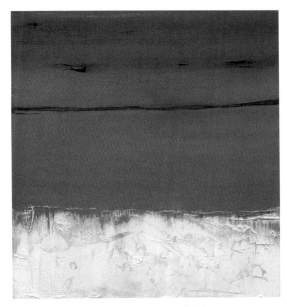

**11** Untitled, 2002 oil, 46x53.5 (private collection, Dublin).

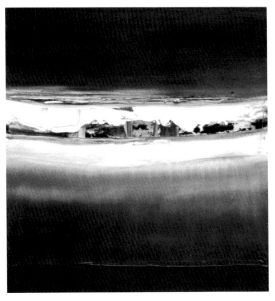

**12** Twilight I, 2002 oil, 46x53 (private collection, Wicklow).

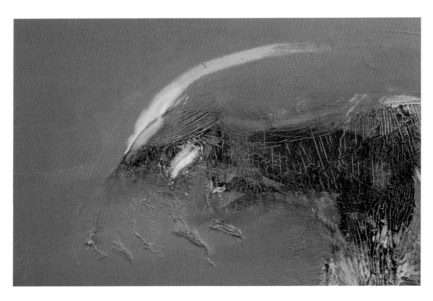

**13** Goat (detail), 2004 oil, 107x122 (Marie O'Kelly).

# ECHOES
## (2004) Drogheda Arts Centre

I do not set out to make paintings about a particular theme, but as the work develops certain motifs, colours and symbols emerge over time. If I try to impose my will on the work it looks contrived and ultimately fails. My aim is to keep the work fresh and alive, to have a sense of mystery and atmosphere and to constantly push the paint to do new things. I have named this body of work Echoes because there is a sense of the past, of its reverberations, and a fascination with what lies beneath.

D. Symes 2004

Leitrim is not a county that generates awe in the way that Galway or Donegal do. As those who live here know only too well, it is a place that grows on one – and you almost have to live here to appreciate it, to come to love the intimacy of the small neglected fields and wild, tumbling hedges. If you are the kind of painter who is receptive by temperament, then it is inevitable that the character of your environment will seep into your skin, finding its way to your bones. Leitrim is a watery, boggy, rocky county, full of lakes, drenched hedgerows and soft, crumbling peat. If you're not looking at the lakes in this county, then you're looking at dark, sodden turf. As local farmers say, there is no 'depth of soil'. There is instead, the black-brown sponge of slowly decomposing sphagnum and rushes, and under that, the mauve-grey 'daub' of subsoil and of course, rock.

Derval Symes is the quintessentially receptive painter. Her work in 'Leitrim Dawn' mirrored the watery skies shot through with fire generated by the alchemy of lakes, clouds and intermittent sun. Though she has always had an affinity with all the elements, her essential orientation has leaned toward the heavier of these, Earth, with its bogs, rocks, roots, fossils, bones and memories. It seemed inevitable then, that when she moved full-time to Leitrim, there would be an engagement with her environment on this other, 'heavier', level.

Though, like many painters, Symes sometimes struggles with the notion of 'freshening' her palette, it is of course largely beyond her control. However, in the way that the place chooses us as much as we choose the place, so also do the colours choose the painter as much as she or he chooses them. On both counts, how could Symes not work with red-browns and blacks and mauves, since these were the colours in which she was now immersed? And so, in 'Echoes' there is a return to the much-loved earth colours after the break with these in the 2002 exhibition. This is familiar territory in terms of palette. In one sense, the success of this work depends upon precisely that familiarity. In some of these paintings, particularly *Goat* (plate 28) and *Ghost Ship* (plate 25) the effects achieved are only possible when there is a long and intense history of relationship between painter and pigment.

There were other notable developments. 'Echoes' consisted of 10 paintings, 5 of which, for the first time since 1998–9 had recognisable figures in them. Where rocks had emerged in 'Excavations', animals began emerging in 'Echoes'.

As I've said elsewhere, Symes' rigour lies in never imposing an image. She will frequently engage initially with a new piece through applying a chaotic and spontaneous layer of paint to a surface. She will then leave this aside, returning to use the canvas perhaps weeks later and beginning with no preconceived idea at all.

There is then, great pleasure in knowing that Symes has not delib-

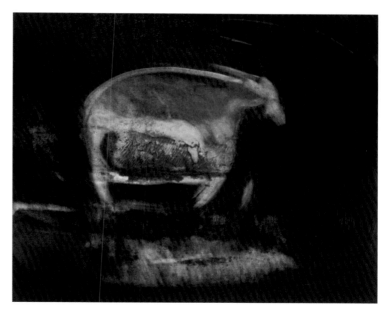

14 Ram, 2004 oil, 54x46 (Maura Hickey).

erately created these creatures or images or indeed the textures, such as the beautiful ragged goat's beard (plate 13). She has 'found' them as she worked. We also 'find' them as we look at her paintings.

What is different in this body of work however, and is rather mysterious given how she paints, is how well defined these images are. For example, the goat in *Goat* (plate 28), the hound in *Hound* (plate 27), or the sheep figure in *Ram* (plate 14), are especially well formed. Symes is one of those painters who can be trusted in her attempts to articulate what she has been doing. She has an innate capacity, once she emerges from it, to name precisely the process she has been through. Her titles are important and accurate. '*Echoes*' is apt as always. Though these creatures are unmistakably present they are also, ambiguously, not of this world. They are echoes. As with all echoes, in order to hear them, we need to listen a little bit longer. Derval Symes has this capacity to listen.

P.K.B. 2005

NOTES

1. From 'Submerged Rhythms', in Mel Gooding, *Painter as Critic, Patrick Heron: Selected Writings*, p. 71 (Tate Gallery Publishing 2001).
2. 'Banon Provence' (2002) by William Crozier at the Boyle Arts Festival 2003, King House, Boyle, Co. Roscommon. Now in Private Collection.
3. For further reading on these matters I recommend, 'Archetypes and Strange Attractors' : J.R. Van Eenwyk Inner Books, ISBN 0-919-12376-7, 'The Voice of the Earth: An Exploration of Ecopsychology', Theodore Roszac (Touchstone 1993), ISBN 0-671-86753-9.
4. *British Journal of Psychotherapy* 21:3 2005, p. 433.
5. 'Pierre Bonnard and his Abstractions', in Mel Gooding, *Painter as Critic, Patrick Heron: Selected Writings*, p. 22 (Tate Gallery Publishing 2001). 'Every painter has (his) own variety of abstract shapes thus concealed – and often only just concealed – beneath (his) more or less naturalistic compromise with appearances, beneath a finish that is 'like'.
6. 'Constructions in Colour and Light: an Interview with William Crozier' in: *Irish Arts Review*, Spring 2003.

earthworks

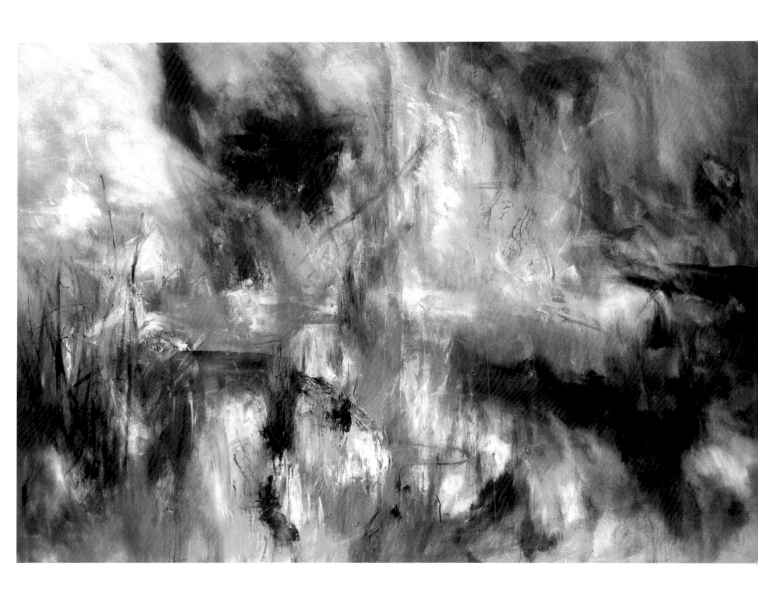

**15** Earthfire, 1990–91 oil, 213x153 (Deirdre Masterson).

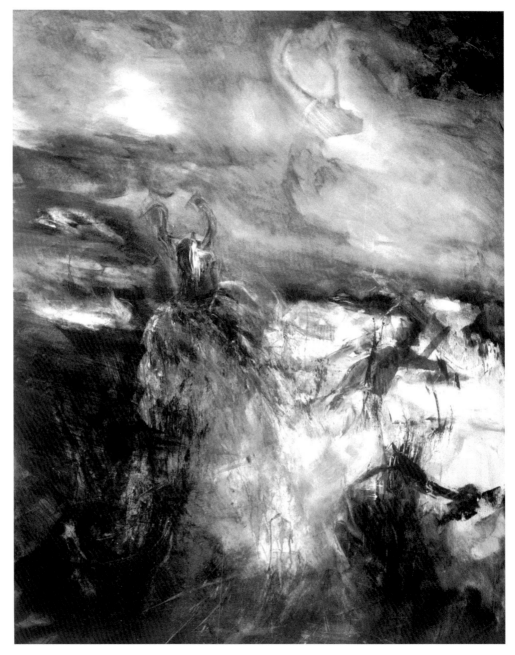

**16** Viking, 1994 oil, 107x141 (Oran and Catherine Symes).

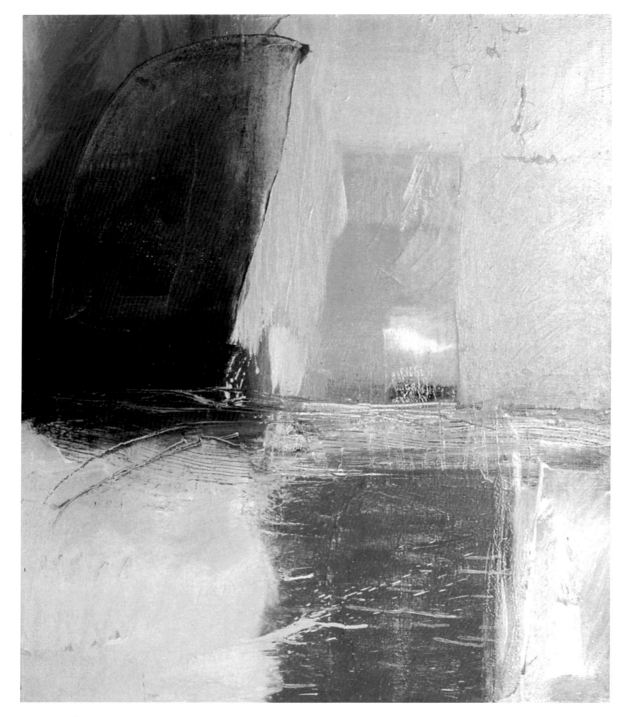

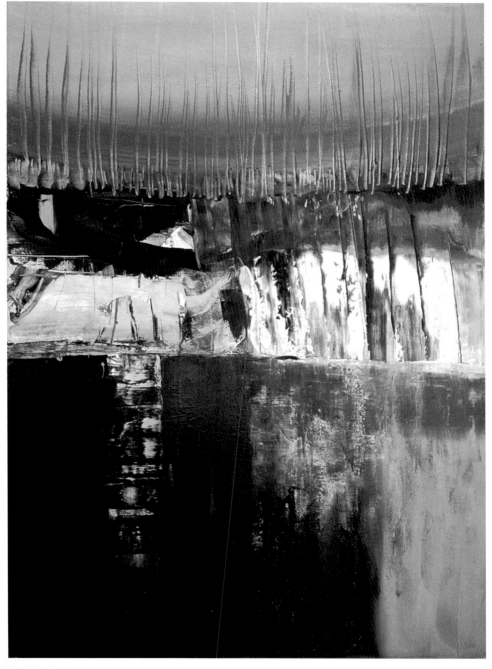

[left] **17** Whale, 1998–9 oil, 80x66 (private collection, Europe).

**18** Grass Roots, 2001 oil, 77x107 (private collection, Dublin).

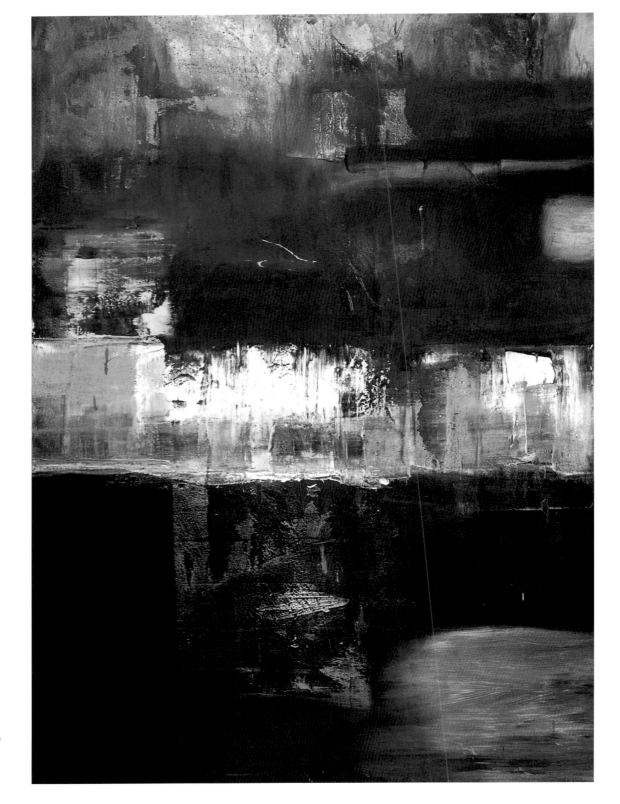

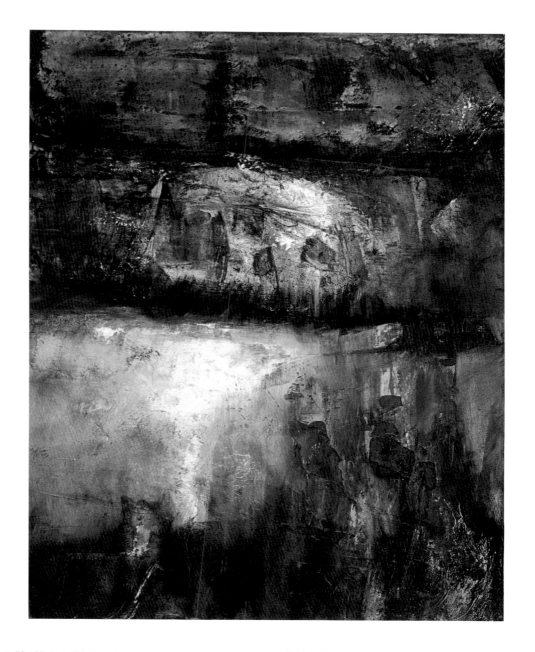

[left] **19** Fools Gold, 2001 oil, 78x109 (Orla and Peter Kearney).

**20** Moss Stone, 2001 oil, 60x76 (private collection, Roscommon).

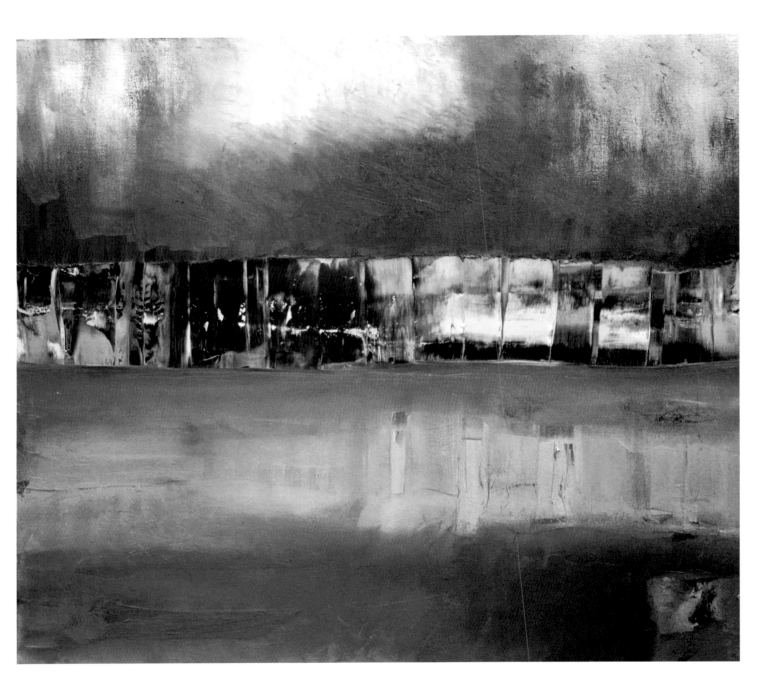

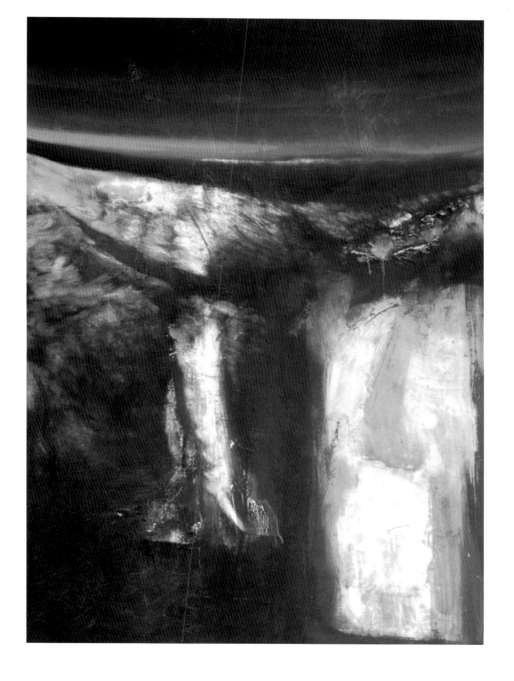

[left] 21 Twilight II, 2002 oil, 102x91.5 (private collection, Dublin).

22 Shoreline, 2002 oil, 78x110 (Marie O'Kelly).

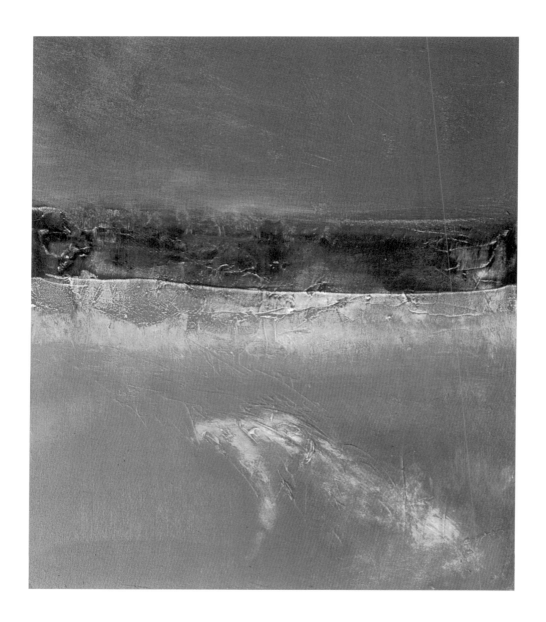

**23** Submerged, 2003 oil, 46x53.5 (pivate collection, Drogheda).

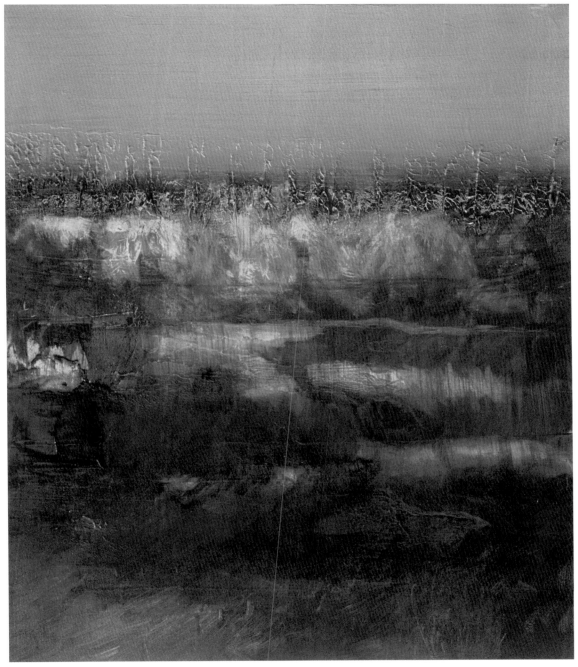

**24** Bog, 2003 oil, 45.5x53.5 (private collection, Drogheda).

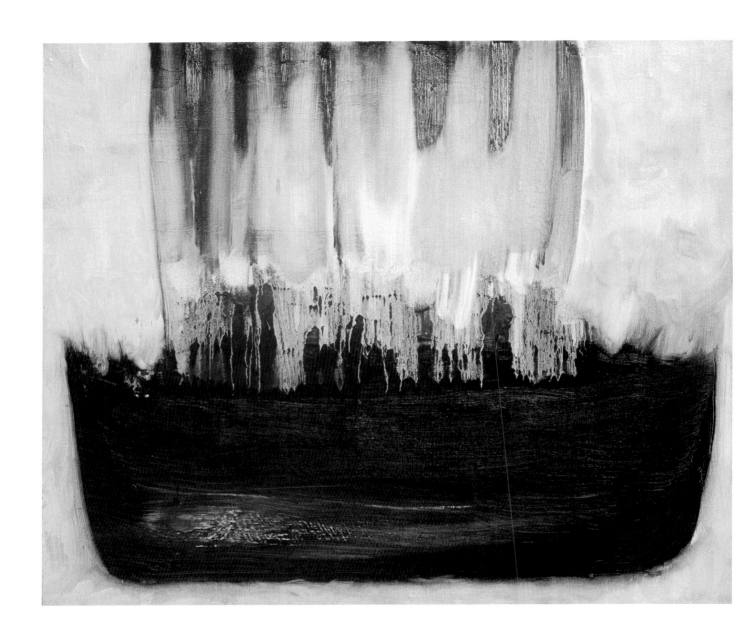

**25** Ghost Ship, 2004 oil, 54x46 (Fiona Ward).

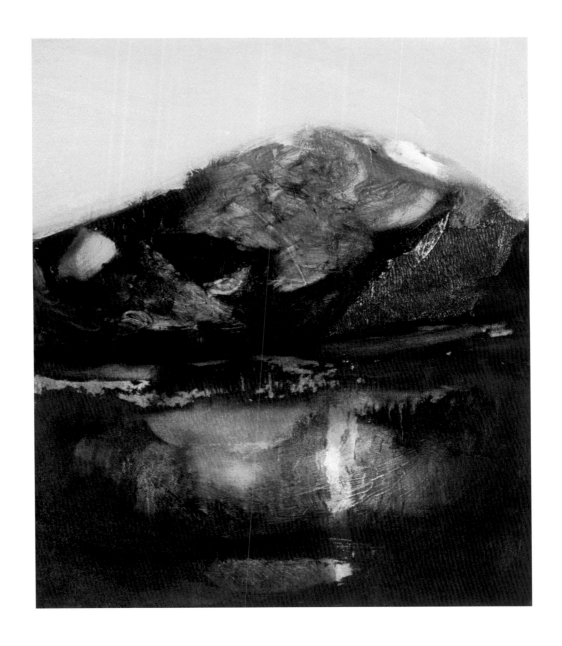

**26** Mountain, 2004 oil, 45.5x53.5 (private collection, Dublin).

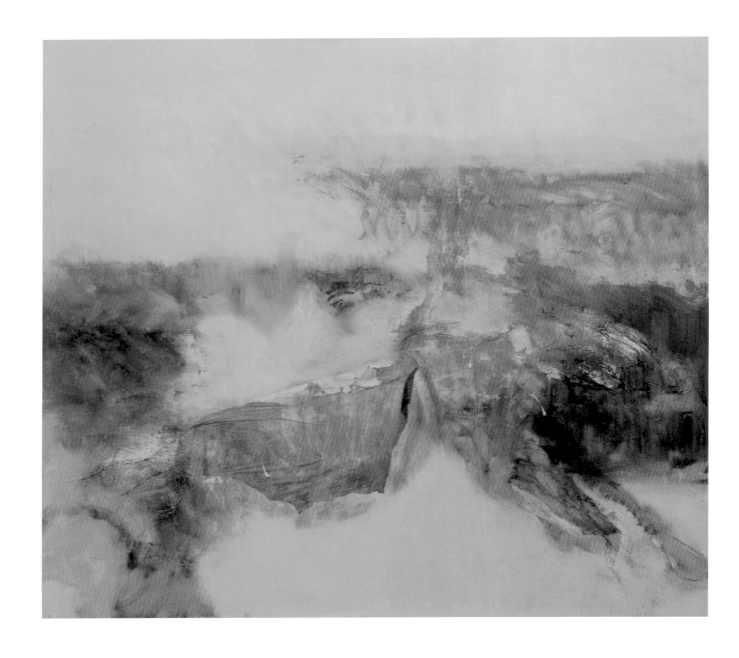

**27** Hound, 2005 mixed media, 91x102 (collection of the artist).

## GOAT

This is a mysterious and beautiful painting. I first saw it in Symes' loft, waiting, with all the other completed paintings, to be transported to the Drogheda Arts Centre for her 2004 'Echoes' exhibition. Symes had been complaining in the months leading up to the show that she wanted to use different colours. She was trying to get away from the earthy tones that have been her mainstay over recent years. She was making valiant daily attempts to squeeze other less familiar pigments on the big melamine board she uses as a palette. I had heard mutterings about blues, greens and cadmiums.

However, when I came up the shaky ladder to the attic and stuck my head through the trap door, I realised that, far from getting away from these umbers and siennas and ochres, Symes had, as it were, become even more helpless in their grasp. The space was awash with browns and golds and reds on canvases of varying sizes. Paintings jostling in a room together are like animals or people – there is always a leader, a presence to be reckoned with. We know who they are because we can't stop looking at them… Looming before me on this occasion was a glowing burnt-orange canvas. From the angle I was at I couldn't make out much of the content. However, I knew at once that I had met the leader of the herd, the painting that would hold the soul of the exhibition. It was 'Goat'.

The composition of this painting is fairly straightforward. The canvas is roughly divided between top and bottom, with an almost central image uniting them. There is nothing very unusual then, about the way the space across the surface is used.

So how does this work command attention?

The burnt-orange glow that had first caught my eye is primarily in the lower half of the canvas. It is a superbly intricate area of paint covering about two by four feet in a rough-hewn rectangular shape, and consisting (perhaps) of burnt sienna in complex combination with raw and burnt umber layered over a creamy white. This area has huge natural variation in it and takes up a lot of the viewer's 'eye-time' when pouring over the surface. To the right, pinkish brushwork is visible in fast and thin turpsey strokes. Below and to the left edge of the canvas, there is thicker, more cloying paint. Further in toward the centre of the shape there are areas of burnt or raw umber that look distinctly fractured, or broken or washed away– 'weathered' is the word that springs to mind. The area to the left of this is again textured, but more finely so. Some material (crunched up newspaper perhaps) has been applied here to the wet paint and, when it was pulled off, left a myriad of tiny marks that resemble the skeletal remains of leaves as they are found midwinter. All of these passages, and the thick creamy white that sits at the top of the rectangle, are enjoyable in themselves. They are not where the real pull is however. The strongest part of this area is further down, at the 'heart' of the painting. This is where the real magic resides. We 'settle' here because here is not 'settled'. We work back and forward between several different shifts of perception and understanding. This rectangular shape, which we have begun to inadvertently accept as representation of a solid thing – a great boulder with rough and smooth surfaces and endless variations in colour – loses, or surrenders, its capacity to stop our eye at its surface, and we sink 'through'. Suddenly the textures are not on the surface at all but veiling a cavern or empty space. We need another explanation for the flickering reds and oranges which now resemble the embers of a dying fire. Is this a fire inside a transparent rock? Or perhaps not a rock at all, but a cave deep in the bowels of the hot earth?

There are three movements at this point. From the stuff and substance of paint to representation and back again. We move between enjoying the paint surface just as that – delicate, cloying, iridescent, cracked, to enjoying the representation of a 'thing', a boulder, a fire. We move from surface to depth and back again, our eye at one point stopping at the surface, then moving through and 'into', triggering that delicious confusion of sliding between the sensations of bulk and presence and transparency and absence. And thirdly, we move between ambiguous possibilities in representation (a transparent rock lit from within by a fire? a cavern deep in the earth? a boulder on a mountain top lit by a vibrant sunset?) ambiguities which, most importantly, are not resolved.

Giving huge relief from all this activity and 'hotness' is the upper half of the painting.

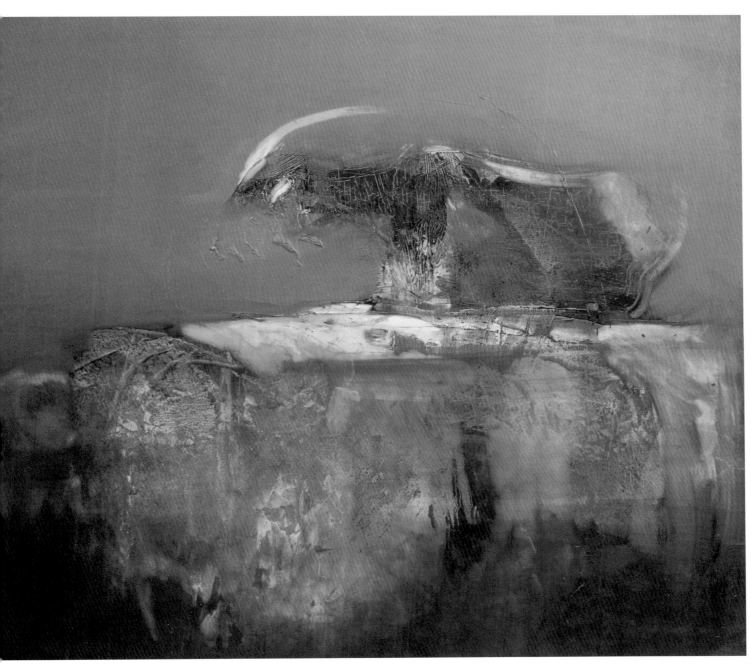

**28** Goat, 2004 oil, 107x122 (Marie O'Kelly).

It is painted in a warm grey-pink-brown. The paint is thick and satisfyingly flat, a wonderful monochromatic resting-place. Here, though there are subliminal textures, the eye is largely undisturbed by traces of brush marks. Immediately we know that here the painter rested, enjoyed painting these smooth sure strokes. After the frenzy and complexity of the passage beneath, this is pure bliss. But this is not empty paint – this is luscious and simple – like having a spoonful of ice-cream after a hot and complicated curry. It reminds me of some of Gary Hume's paint work in its luscious-ness. It isn't often one would consider licking something of this colour (!) but there is a creaminess to it that registers on the tongue.

Between this smooth area and the top of the 'rocky outcrop' there is a creature. It is not defined with lines, there are no discernible legs, but there are 'haunches' at one end and a long 'neck' at the other. This neck is hanging low. The animal could be on its knees with its neck surrendered, out-stretched as for slaughter perhaps, or else about to rise up and peer over the edge of the outcrop. Or perhaps it is emerging, after a great length of time, out of the rock itself? There are areas of broken umber on its neck, resembling nothing other than cracked or broken skin – the kind of skin one imagines would be found on something preserved in a dark bog.

The head of the animal stretches to the left of the painting and here there is perhaps the most beautiful and poignant part of the painting – a 'beard', matted, coarse, with infinite accidental detailing, raised up and sculptural, a definite goat's beard. This is what makes the creature unmistakably goat-like. This beard, unlike the rest of the paint work, is definite, tactile, present. It is sheathed in the same warm grey that coats the top half of the painting. It lies then exactly between the two very different areas of paint – the ephemeral, shifting orange browns and the flat warm grey. It unites these two areas but rises up texturally away from them. It is the absolute focus of the painting to which one's eye returns again and again. After all the ambiguities of the work, it is this small area, no more than 7 square inches, that resolves this painting and fixes it in the visual memory.

DERVAL SYMES

*To get into it takes me forever… I do anything to avoid it so I'll fanny around, I'll make stretchers, I'll wash the floor again I'll do anything but get into the studio, and then when I get in I'm very scared to attack the thing to start with so… I like to think that I'm very organised and I'll mix up loads of different colours – and I do that for a while, but its not constructive it's more putting off – so I'll mix a bit of burnt sienna say with every other colour to see what can I get, add white to each one and I do these little neat colour charts – and that all takes three hours and then I go, Oh its time for lunch… so I go and have a lovely long lunch, it's maybe two hours, watch a bit of telly, come back again in the afternoon… that kind of shit, but eventually I will put something on there… and then eventually you say 'feck this' and you actually start painting and when you start painting without thinking about the time and should I put the kettle on and something happens and you get excited by it and for a long time it might be just muck at the end of the day but you've got something going…*

*D. Symes, Spring 2005*

# DERVAL SYMES

Born April 1964 Dublin

1987–8 Middlesex Polytechnic Art and Design Foundation Course
1988–91 Coventry Polytechnic BA Fine Art

### SOLO EXHIBITIONS

| | | |
|---|---|---|
| Sept 2005 | Earthworks | The Dock Carrick-on-Shannon Co Leitrim |
| August 2004 | Echoes | An Droichead Drogheda Co Louth |
| Sept 2002 | Leitrim Dawn | Powerscourt Town House Centre Co Dublin |
| Aug 2001 | Excavations | The Appleloft Gallery Easkey Co. Sligo |

### GROUP EXHIBITIONS

| | | |
|---|---|---|
| Aug 2003 | | The Appleloft Gallery Easkey Co. Sligo |
| Aug 2002 | | The Appleloft Gallery Easkey Co. Sligo |
| Sept 2000 | Tus | Powerscourt Townhouse Centre Co Dublin |
| Sept 1999 | Machnaimh | The Cobalt Gallery Dublin 1 |
| July 1997 | Convergence Project | Irish Life Exhibition Centre |
| June 1996 | Stones of Identity | Stoneleaf Gallery Dublin 8 |
| Feb. 1996 | A Public Hanging | Stoneleaf Gallery Dublin 8 |
| Dec. 1994 | Powerhouse Exhibition | Pigeon House Hotel Dublin 4 |
| Nov. 1993 | | Pantheon Gallery Dublin 2 |
| Aug. 1993 | Movement | Pigeon House Hotel Dublin 4 |
| March 1993 | Aisling | Pantheon Gallery Dublin2 |
| Aug. 1991 | Fresh Art | Islington Business and Design Centre London |

### BURSARY

Tyrone Guthrie at Annamakerrig, Nov. 2004.

*Works sold to private collectors in Ireland, USA, Belgium and Holland. Also held in collections in AMB Ireland, Loredo Ltd and Gael Linn.*

*set in* Monotype Bembo
*founts on cover* misproject and broken 15, *see* www.misprintedtype.com
*printed in* Belfast by Nicholson and Bass
*published by* BackYard Books
September 2005

thank you to our generous sponsors who made this publication possible

Patricia Scanlon and Ritchie Flynn
Amrop Hever International, Co. Dublin
Reynolds Topline Hardware, Carrick on Shannon, Co. Leitrim
The Bookshop, Carrick on Shannon, Co. Leitrim
Gabriel Toolan, Ballinamore, Co. Leitrim
The Landmark Hotel, Carrick on Shannon, Co. Leitrim
County Leitrim Partnership, Drumshanbo, Co. Leitrim
Mulveys Gift Shop, Carrick on Shannon, Co. Leitrim